Tortitude

The BIG Book of Cats with a BIG Attitude

By Ingrid King

Ingrid King brings all of her talent, skill and heart to the job of setting the tortie record straight. She has taken the stereotype, turned it on its head, and opened the world's eyes to the true meaning of tortitude."

- **Jackson Galaxy,** Host of AnimalPlanet's **My Cat From Hell** -

With a Foreword by Kate Benjamin

Copyright © 2016 by Ingrid King
Published by Mango Media Inc.

Front Cover Image: Laura Mejia , **photo by Ingrid King**
Back Cover Image: Laura Mejia, **photo of Jackson Galaxy by Russell Baer**

Cover Design: Laura Mejia
Interior Design, Theme and Layout: Elina Diaz and Laura Mejia.

ISBN 978-1-63353-293-9

For Allegra and Ruby

In loving memory of Amber, Buckley and Feebee

Also by Ingrid King

Buckley's Story: Lessons from a Feline Master Teacher

Purrs of Wisdom: Conscious Living, Feline Style

Adventures in Veterinary Medicine: What Working in Veterinary Hospitals Taught Me About Life, Love and Myself

Praise for Tortitude: The Little Book About Cats With a Big Attitude

"To call torties misunderstood would be the understatement of the year; the misinformed and uninitiated might just see them as moody, grouchy or mean! In this book, Ingrid brings all of her talent, skill and heart to the job of setting the tortie record straight. Anybody who has had the honor of sharing their life with a tortie (like me, as you can see from these pictures of my dear departed Chuppy) owe Ingrid a debt of gratitude, because she has taken the stereotype, turned it on its head, and opened the world's eyes to the true meaning of tortitude."

–Jackson Galaxy, Host of Animal Planet's **My Cat From Hell**

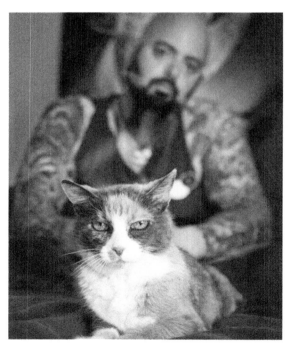 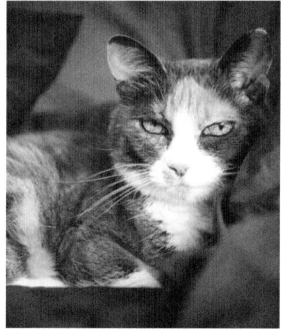

Photos by: Susan Weingartner

A delightful collection of fascinating information and scientific facts coupled with adorable photos and whimsical quotations. It's the perfect book for any cat lover - not just those who are owned by torties!

- **Angie Bailey,** award winning author of **Texts from Mittens and Whiskerslist: The Kitty Classifieds**

Praise for Buckley's Story: Lessons from a Feline Master Teacher

Buckley's Story is a true celebration of the bond between pets and their humans. This story of a "gimpy" little tortoiseshell cat with a huge heart who changed her human's life in unexpected ways shows us how pets teach us universal lessons about living a joyful life, how caring for a terminally ill pet can deepen this special bond, and how to navigate the devastating grief that comes with losing a beloved animal companion.

– **Dr. Marty Becker,** "America's Veterinarian" and author of **The Healing Power of Pets: Harnessing the Amazing Ability of Pets to Make and Keep People Happy and Healthy**

Purrs of Wisdom: Conscious Living, Feline Style

"Purrs of Wisdom is the perfect book for anyone who loves cats and has an interest in living life to the fullest, with a positive and peaceful outlook, just like a cat does! It spoke to me on several levels and is sure to become a well-thumbed volume as I continue on my life's journey."

– **Ann Brightman,** Managing Editor, **Animal Wellness Magazine**

Table of Contents

Foreword

By Kate Benjamin

I was first introduced to the true meaning of tortitude by Flora. She was five pounds of fierce packed into a beautiful little tortoiseshell cat. I met her at an adoption event where I asked the volunteers to please show me a cat that they thought wouldn't be pushed around by my alpha cat, Ando. Little did I know that this tiny tortie would be the perfect new addition to my household.

Flora was full of attitude from the moment I met her. Actually, upon entering the meet and greet area, she proceeded to tear me up along with the volunteer accompanying me, prior to peeing on both of us.

You see, Flora had been rescued from a hoarding situation where she was living with 700 other cats. When Best Friends Animal Society was called in to help with the case, they found that many of the cats were not socialized or had become afraid of humans. Flora was one cat who didn't trust humans very much, but I knew she needed a loving home with someone who understood her and was willing to give her the space she needed to learn to trust again.

The moment Flora met Ando, she was instantly in love with him. This made me realize that she fully trusted other cats, but humans, not so much. I observed how she always stood up for herself (all my worries about Ando pushing her around disappeared immediately). She was quick to get her meals, even with other cats around, and she was very clear about communicating when I crossed her comfort line.

As I was getting to know Flora's personality, I heard about the feisty characteristics often associated with tortoiseshell cats. The description fit her perfectly. I then

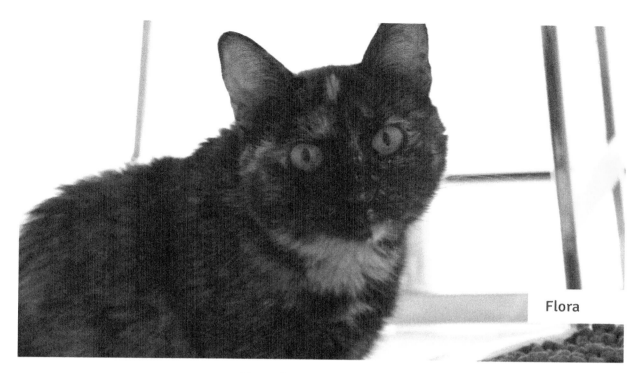

Flora

Photo by: Kate Benjamin

realized that this extra spunk must have been one of the things that got her through the terrible situation she had been in. Her tortitude helped her survive.

Over the years she grew more and more trusting and really came to be a sweet, loving little cat. The look in her eyes always let you know that she was in charge and she never stopped raising a paw if she needed to make a point. Up until her last days with me, she slept by my head every night, something I never thought I would see. Her tenacity and spunk was present until the very end when her little body decided it was done. She was a wise old soul.

Soon after I adopted Flora, I actually added a second tortie to my family. Dazzler was also from the same hoarding situation, although she was much more social than Flora had been. For some reason, I thought that these two torties would be fast friends. That wasn't exactly the case, they didn't really bond, but they were happy to co-exist.

Dazzler has a whole different kind of tortitude than Flora had. Dazzler is what I call a "cat cat," meaning that she prefers cats over humans. She tolerates me in a very tortie kind of way, but she absolutely loves the other cats. Whenever I try to show her affection I'm met with indifference or

slight irritation. Despite that, she has my unwavering love because she is round and adorable and she has bunny-soft fur. When she does come over to me for the occasional pet, it is quite rewarding.

I do truly believe that my two torties have distinctive personalities, unlike any of my other non-tortie cats. Torties are each unique but with a unifying spirit that is endearing and intriguing. I'm thrilled to see this celebration of these distinguished cats and hope that you enjoy this deeper look into who they are and what they mean to the people who love them.

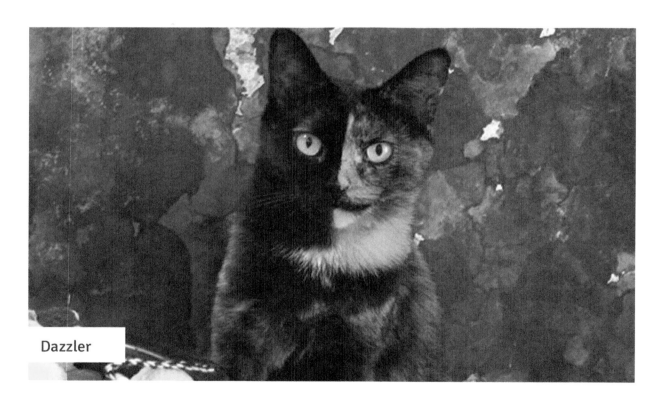

Dazzler

Photo by: Kate Benjamin

Photo by: Matty Steinkamp

Kate Benjamin

Founder of Hauspanther and New York Times bestselling co-author of **Catification: Designing a Happy and Stylish Home for Your Cat (and You!)**

Introduction

In August of 2009, I wrote a post titled Tortitude: The Unique Personality of Tortoiseshell Cats for The Conscious Cat. The post generated more than 14,000 comments over a period of less than five years. It became a place for people to share stories about their torties, as these beautifully colored cats are affectionately known. In September of 2014, I wrote an updated version of the post, titled "Tortitude – The Unique Personality of Tortoiseshell Cats: Fact or Fiction," which ranks at the very top of a Google search for the term "tortitude." This post gets about 400 views every single day. Clearly, there are a lot of people out there who adore tortoiseshell cats and want to learn more about them.

I've been owned by tortoiseshell cats, affectionately known as "torties" by those of us who love these beautifully colored cats, for the past two decades. It all started with Virginia, a high-spirited little cat who I first met during an interview for the hospital manager position at the Middleburg Animal Hospital in Middleburg, Virginia. The hospital was then owned by Drs. Jack Love and Janet McKim, a husband and wife team. I had spoken to Janet on the phone briefly before my interview, but really didn't know what to expect. This was in the days before every animal hospital had a website. I knew what I was looking for in a potential employer as far as practice philosophy. I was looking for a clinic that had that intangible right "feel."

As soon as I walked into the waiting room of the hospital, I knew I had found the right place. There was an old-fashioned wooden bench, a rocking chair, and the walls were covered with photos of dogs and cats. A large free-standing cage held several kittens. When Janet came up to greet me, I was even more sure. I instantly liked her. She took me back to her office and began the interview.

After a few minutes, a beautiful tortoiseshell cat walked into the office. "That's Virginia," explained Janet. "She's one of our two hospital cats." Virginia proceeded to walk over to me, looked up at me, and then dug her claws into my legs and used them as a scratching post. I wondered whether that was part of the interview – a test, perhaps, to see how I would react? In hindsight, I realized that, of course, this was the moment she marked me as her own. I had dressed up for the interview and was wearing a skirt and pantyhose. I would venture to say that not many people could boast leaving an interview with runs in their pantyhose caused by kitty claws and actually think that was a good thing. The interview went well in other ways, too, and I left feeling cautiously optimistic that I would be offered the job.

A couple of weeks later, Janet called to invite me to go out to dinner with her and Jack. We sealed the deal over dinner, and I spent the next eight wonderful years working at the animal hospital. The fact

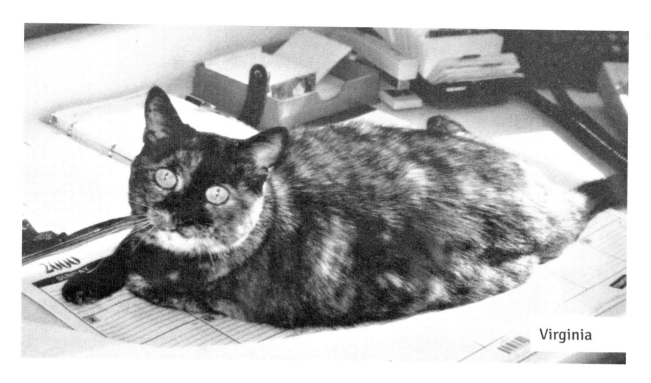

Virginia

Photo by: Ingrid King

that Virginia was part of the deal only increased my happiness.

She was estimated to be about ten years old. She was FIV positive. FIV is the feline version of the aids virus. It is contagious, but is primarily spread through bite wounds. Casual, non-aggressive contact does not spread the virus, and it is not zoonotic, which means it cannot be spread from cat to humans. However, Virginia's owners were not comfortable keeping an FIV positive cat and had left her at the animal hospital for euthanasia. Somehow, the hospital staff never got around to it,

and by the time someone remembered, she had wormed her way into too many hearts for anyone to be able to go through with it.

Virginia was the poster child for tortitude. She was feisty, independent, and set in her ways. The only other animal she liked was Marmy, our other hospital cat, a sweet, wise old medium-haired orange cat. You could often find Marmy in his cat bed, with Virginia curled around him, squeezed into the small bed with him.

She liked most of the staff members, but this was not always mutual. She thought

nothing of using her claws if she felt that someone wasn't doing her bidding (i.e., petting her properly, feeding her on her schedule, or committing any number of transgressions only she knew about). None of these were exactly qualities you'd look for in a hospital cat. At one point, early on during my time as manager, there was talk of sending her to a nearby sanctuary for FIV positive cats. I was nervous about doing so, but I set an ultimatum: if Virginia went, so would I. Thankfully, by then Janet and Jack had come to rely on me, and took my "threat" seriously. Virginia got to stay.

She loved me fiercely. She would be at the office door to greet me each morning. When I took a few days off, the staff would tell me that she'd been looking for me all over the hospital. When I returned to work, the look on her face made it clear that she did not appreciate being abandoned like that. She had her routine, and it didn't vary much from day to day. In the morning, she'd sleep in a cat bed I had placed in front of a sunny window on my desk, next to my computer. She'd spend most mornings napping, but she also made sure that I paid attention to her, often clawing at my "mouse hand" to get my attention. As lunch time got closer, she would park herself on the bench in the exam room adjacent to my office, where most of the staff gathered for lunch each day. She loved to mooch off of peoples' lunches. Morsels of meat, chicken or cold cuts were her favorites, followed closely by yogurt, especially the peach flavored kind.

For four years, she made my office my home away from home. She showed no symptoms of her disease. Then, in the spring of 2002, she started to decline rapidly. She seemed to lose energy, and her always healthy appetite started to wane. She couldn't make it to the litterbox in time and had frequent accidents outside the box. She wouldn't come to greet me at the door in the mornings. An ultrasound showed that her heart and liver were in bad shape.

On a sunny April morning, we decided that it was time to let her go. I spent her last morning in the office with her in her bed by my side. When I wasn't crying, I was calling staff members who were not on duty that day to let them know, in case they wanted to be present for her final moments. I held her on my lap in the office, surrounded by all the people who had been a part of her world, as she took her last breath. I don't think there are many cats who got the kind of send off she did.

After Virginia came Amber. Amber and her five kittens were brought to the Middleburg Animal Hospital in the spring of 2000 by a client who had found the little family in her barn. Despite being emaciated and scrawny-looking, Amber's eventual beauty was evident even then. She is a dark

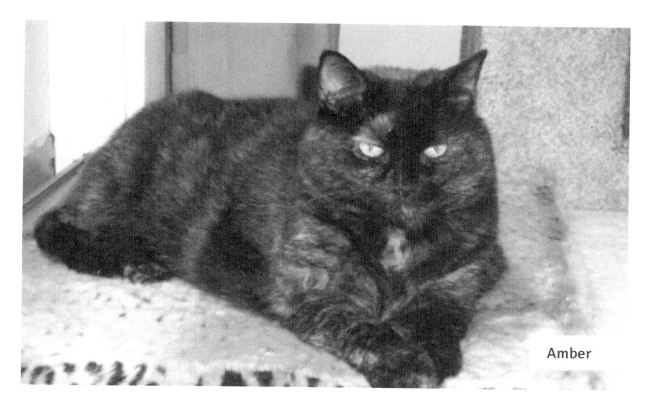

Amber

Photo by: Ingrid King

Tortoiseshell color, with an amber-colored heart-shaped spot on top of her head, which became the reason for her name. Her kittens found new homes in fairly rapid succession.

However, nobody was interested in the beautiful mommy cat. She spent her days in the big adoption cage in the hospital's waiting area, but with the constant inflow of homeless kittens that is typical for spring and summer, nobody wanted to adopt an adult cat. I had recently lost my almost sixteen-year-old soul mate cat Feebee, and

the grief over his loss was still very fresh. I did not think I was ready for another cat, but coming home to an empty house was becoming increasingly difficult.

One weekend in July, I decided to take Amber home, "just for the weekend". I wanted to give her a break from the abandoned feral kitten we had placed with her after her own kittens had all found homes. The kitten was a rambunctious six-week old grey tabby, and Amber was becoming increasingly exasperated with

his constant need for attention. As far as she was concerned, she had done her mommy duty with her own kittens.

After living in a cage for all these months, Amber was initially a little overwhelmed by having access to an entire house, and she spent most of that first weekend near or under my bed. By Sunday evening, she had relaxed a little and started exploring her new environment. I liked having her gentle and peaceful energy around the house, and I decided that she could stay a little longer. Not quite ready to acknowledge that she was home with me to stay, I told everyone that I was "just fostering her".

Somehow, the flyers advertising that she was available for adoption never got distributed, and she only returned to the animal hospital for regular check ups.

Amber was a wise old soul in a feline body, and the inspiration for **The Conscious Cat**. Sadly, she passed away in May of 2010 after a sudden, brief illness.

Buckley came into my life in the spring of 2005. After Virginia died in 2002, my office at the animal hospital felt empty, but the right cat to succeed Virginia in the very important position of office cat had not come along – until that spring day, when I walked into the kennel area of the hospital and saw a cute little tortie in one of the cages all the way in the back. She immediately came to the front of the cage and rubbed up against the bars. When I opened the door, she practically threw herself at me. I fell in love. Hard. And fast. After that first encounter, I knew that she would become my new office cat.

A year later, I left my job at the animal hospital to start my own business. Initially, I thought I could live without Buckley. Amber had been an only cat for six years and I wasn't sure whether she would accept another cat. Eventually, I missed Buckley too much, and when I got a call from one of the animal hospital's receptionists telling me that a client was interested in adopting Buckley, there was no more hesitation on my part. Buckley came home with me, and shared Amber's and my life for the next two years, before she passed away from complications related to her heart disease. Buckley changed my life in ways I never could have imagined and inspired my first book, **Buckley's Story: Lessons from a Feline Master Teacher**.

I currently share my life with Allegra and Ruby, two young tortoiseshell cats who came to me at seven and nine months of age, about a year apart. They both have tortitude in spades.

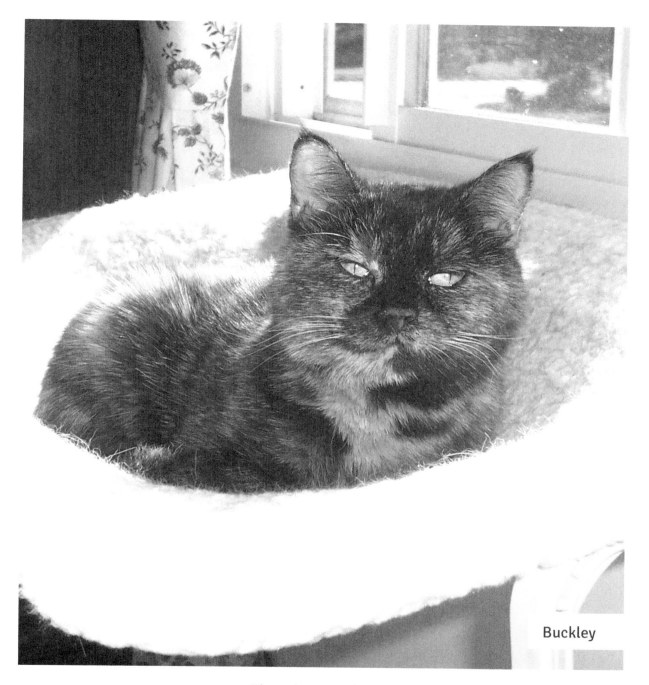

Buckley

Photo by: Ingrid King

Allegra & Ruby

Photo by: Ingrid King

What is Tortitude?

Tortoiseshell cats, also affectionately known as "torties" among their admirers, do not just stand out because of their distinctive coloring. They also have a reputation for unique personalities, often referred to as "tortitude." They tend to be strong-willed, a bit hot-tempered, and they can be very possessive of their human. Other words used to describe torties are fiercely independent, feisty and unpredictable. They're usually very talkative and make their presence and needs known with anything from a hiss to a meow to a strong purr. These traits appear to be stronger in tortoiseshell cats than in calicos – it seems as though these traits are somewhat diluted with the addition of more white to the color scheme.

What is a tortoiseshell cat?

Tortoiseshell cats are not a breed. They are named for their distinctive coloring – a combination of patches of black, brown, amber, red, cinnamon and chocolate. The size of the patches can range from a speckled pattern to large splotches of color. The term "tortoiseshell" is used for cats with brindled coats with very few or no white markings, as opposed to calicos, who are tri-colored cats with larger areas of white fur. There is some debate as to how much white a cat can have and still be considered a tortoiseshell.

Sometimes, the tortoiseshell colors are more muted and present in lighter versions such as lilac or cream. Torties with this lighter coloring are called dilute torties. Very dark torties with a lot of black in their fur are often affectionately called "chocolate torties." Occasionally, the typical tortoiseshell colors are also seen in a tabby (striped) pattern; these cats are referred to as "torbies." Tortoiseshell markings appear in many different breeds.

The unique genetics of tortoiseshell cats

In addition to their unique personalities, torties also have unique genetics. The vast majority of tortoiseshell cats are female, because two X chromosomes are required to produce the black, gold and orange coloring. Male cats must have one X and one Y chromosome, so technically it's genetically almost impossible for a male to inherit the tortoiseshell coloring. A male tortoiseshell has an extra X chromosome, making it an XXY. According to a study by the College of Veterinary Medicine at the University of Missouri, only 1 in 3000 tortoiseshell cats is male.

Are tortoiseshell cats really different from other cats?

While there are some commonalities between torties when it comes to personality, there seem to be wide variations in the degree of tortitude and in how it is expressed. Some cats appear to have read the book on tortitude, displaying all the traits attributed to cats with this coloring. Others may vary in temperament, and only demonstrate certain aspects of it. All cats are individuals, and torties are no different in that respect, with the possible exception that they are far more demonstrative of their unique personalities than cats of other colors.

The experts weigh in on tortitude

I decided to check with some experts to get their thoughts on tortitude. "I often tell clients that torties are the redheads of the cat world," says feline veterinarian Dr. Fern Crist, who practices at Just Cats Clinic in Reston, VA. "They are beautiful, but short-tempered and quick to wrath. Of course, they are not all like that, any more than every redhead is – but I always approach a tortie with a tad more circumspection than any other coat color." While Crist takes a cautious approach to her tortie patients, she adds, "I've always thought that the price you pay in tortitude, you get back tenfold in love."

"There is no evidence that there is a link between color gene and personality," says Dr. Elizabeth Colleran, a former president of the American Association of Feline Practitioners and owner of two cat hospitals, Chico Hospital for Cats in Chico, CA, and the Cat Hospital Of Portland in Portland, OR. "It is true though, that almost all tortoiseshell cats are females, and some people perceive females as being more headstrong than male cats. However, the real determination of personality is naturally a combination of genetics and environment."

Jackson Galaxy, a feline behaviorist and star of Animal Planet's "My Cat From Hell," has worked with his share of tortoiseshell cats in his decades of helping cats with behavioral challenges. "In my experience, tortitude is a very real thing," says Jackson. "And now that there is a study correlating coat pattern with behavior, our characterizations have been validated. Of course, anyone who knows me knows I try not to talk about cats in generalities." Jackson feels that torties and calicos are more energetically sensitive. "I think that's part of the reason why their personalities are always on full display," he says. "I've always said that cats are energetic sponges. Torties, however, just seem to soak up more, which is why they've got so much to say."

Tortoiseshell cats are special

Those of us who love torties embrace their unique personalities. It is important to remember that every cat, regardless of coat color, is an individual. Not every tortie will exhibit the traits attributed to these cats, but the majority seem to live up to their reputation. As far as I'm concerned, tortitude is real. And while torties may, at times, seem like they have split personalities, going from purring away in your lap to suddenly racing around the house like a crazy kitten, those of us who love them wouldn't want them any other way.

Facts About Tortoiseshell Cats

A Brief Primer on Tortoiseshell Cat Genetics

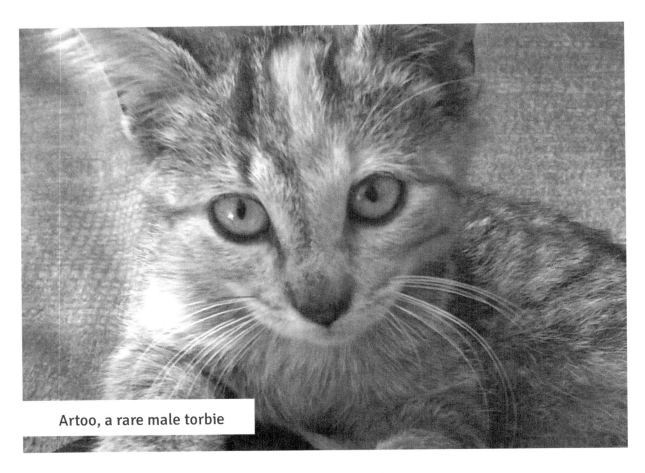

Artoo, a rare male torbie

Photo by: Shelby Baker

Personality isn't the only thing that's special about torties. The tortoiseshell coat color is the result of a combination of genetic and developmental factors.

A cat's main color is determined by a primary coat color gene. The tortoiseshell pattern is determined by two co-dominant genes, in other words, two genes that are expressed at the same time and affect each other. In a bi-colored tortie, these two genes comingle to produce the characteristic brindled tortoiseshell pattern. In dilute torties, these genes are modified by a recessive gene, which results in softer coat colors. Black becomes grey, orange becomes cream.

Gender in cats is determined by two types of chromosomes - the X chromosome and the Y chromosome. Normal female cats have two X chromosomes in their DNA, and normal male cats have one X and one Y chromosome. The two co-dominant genes that produce the tortoiseshell pattern are both only on the X chromosome. The red, yellow or orange color is caused by the "O" (for orange) gene. The O gene changes black pigment into a reddish pigment. The O gene comes in one of two alleles (versions): O (orange) or o (not orange). An XO-XO

combination will result in an female orange or marmalade cat, an Xo-Xo combination in a female black cat. A cat with both XO and Xo alleles will have a tortoiseshell pattern.

Since two X chromosomes are required to produce the black, gold and orange coloring, the vast majority of tortoiseshell cats are female. Male cats must have one X and one Y chromosome, so technically it's genetically almost impossible for a male to inherit the tortoiseshell coloring. A male tortoiseshell cat has an extra X chromosome, making it an XXY. According to a study by the College of Veterinary Medicine at the University of Missouri, only 1 in 3000 tortoiseshell cats is male. Due to the chromosome imbalance, male tortoiseshell cats are sterile.

A tortoiseshell cat may have a distinct tabby pattern on one of its colors. This pattern is driven by yet another gene. Tabby cats, also referred to as tiger cats, are cats with a coat featuring a pattern of distinctive stripes, lines, dots or swirling patterns. These cats are known as torbies, and, like all tortoiseshell cats, are predominantly female.

Tortoiseshell is Not a Breed

Tortoiseshell markings appear in many different breeds. The breeds listed below can all exhibit tortoiseshell patterns:

Abyssinian

Tonkinese

Birman

Turkish Angora

American Bobtail Cat

British Shorthair

Himalayan

Burmese

Maine Coon

American Curl

Burmilla

Colorpoint Shorthair

American Wirehair

Scottish Fold

Devon Rex

European Shorthair

Cornish Rex

Somali

Manx

Japanese Bobtail

Siamese

Norwegian Forest Cat

Persian

Sphynx

Turkish Van

Tortoiseshell Cat Folklore

Tortoiseshell cats have a mythical folklore in many cultures, much of it centered around the rare male tortoiseshell. The Celts considered it a good omen if a male tortoiseshell stayed in their home. English folklore has it that warts could be healed if rubbed by the tail of a male tortoiseshell's tail during the month of May. Japanese fishermen believed that male tortoiseshells protected their ships from storms and ghosts. A Khmer legend in South East Asia has it that the first tortoiseshell arose from the menstrual blood of a goddess born of a lotus flower.

Torties are thought to bring good luck in many cultures. They are sometimes referred to as the money cat.

Tortoiseshell cats were believed to have psychic abilities and see into the future. It is said that those who dream of a tortoiseshell cat will be lucky in love.

Quotable Torties

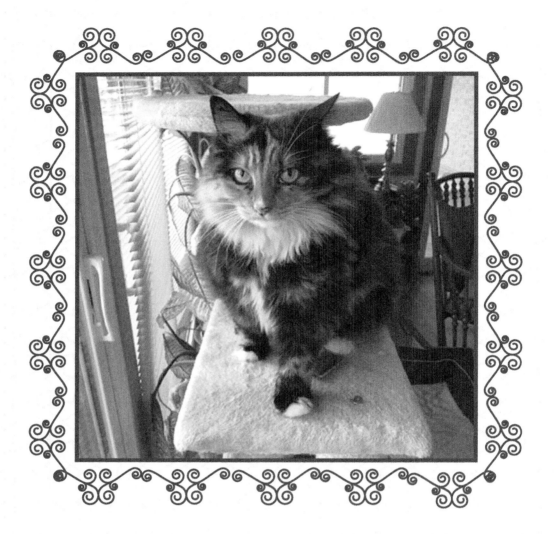

Gigi, Fort Erie, Ontario

Photo by: Glen Bowley

I love cats because I love my home and little by little they become
its visible soul.
– Jean Cocteau

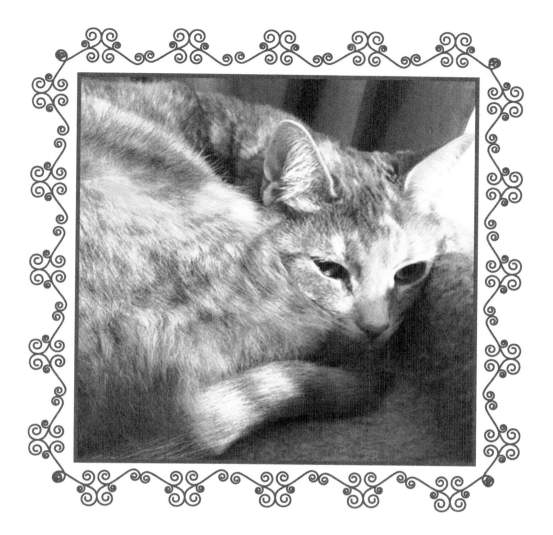

Sophie, Perry Township, OH

Photo by: Barbara Betts

There are people who reshape the world by force or argument, but the cat just lies there, dozing, and the world quietly reshapes itself to suit his comfort and convenience.
— **Alan and Ivy Dodd**

Allegra

Photo by: Ingrid King

Happiness does not light gently on my shoulder like a butterfly. She pounces on my lap, demanding that I scratch behind her ears.
– **Unknown**

Ariel and Duffy, Tampa, FL

Photo by: Adrienne Curtis

If you want to be a psychological novelist and write about human beings, the best thing you can do is own a pair of cats.
— Aldous Huxley

Belle, Middleburg, VA

Photo by: Nancy McMahon

Never ask a hungry cat whether he loves you for yourself alone.
— Dr. Louis J. Camuti

Sarah, Los Angeles, CA

Photo by: Carolyn Miller

You can't look at a sleeping cat and be tense.
— **Jane Pauley**

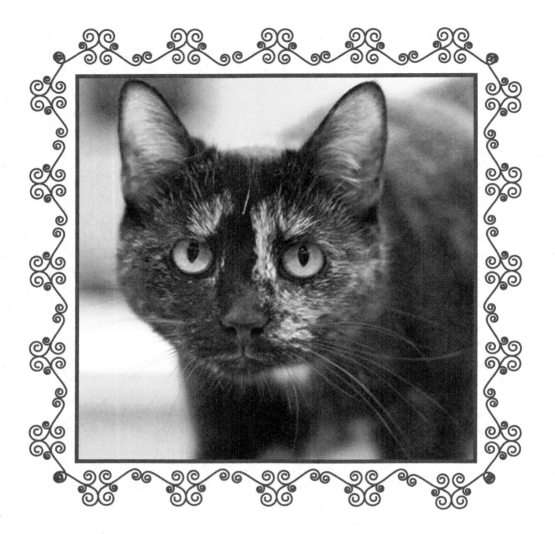

Fiona, Orlando, FL

Photo by: Anonymous

There are many intelligent species in the universe. They are all owned by cats.
— Anonymous

Kajsa, Stockholm, Sweden

Photo by: Maria Timashans

If a fish is the movement of water embodied, given shape, then cat is a
diagram and pattern of subtle air.
— Doris Lessing

Lucy, Sydney, Australia

Photo by: Elizabeth Moore

Time spent with cats is never wasted.
– Colette

Lexy, Orlando, FL

Photo by: Debbie Johnson

In ancient times cats were worshipped as gods; they
have not forgotten this.
- **Terry Pratchett**

Kasey, Fort Erie, Ontario

Photo by: Glen Bowley

After scolding one's cat, one looks into its face and is seized by the ugly suspicion that it understood every word and has filed it for reference.
— Charlotte Gray

Truffles, Elk Grove, CA

Photo by: Elaine Faber

Cats are dangerous companions for writers because cat watching is a near-perfect method of writing avoidance.
— Dan Greenburg

Gigi, Raleigh, NC

Photo by: Jessica Lawrence

Your cat will never threaten your popularity by barking at three in the morning. He won't attack the mailman or eat the drapes, although he may climb the drapes to see how the room looks from the ceiling.
– Helen Powers

Allegra

Photo by: Ingrid King

I have noticed that what cats most appreciate in a human being is not the ability to produce food, which they take for granted – but his or her entertainment value.
— Geoffrey Household

Kitsune, White Wind Zen Community, Ottawa

Photo by: Shiaki Zuiko

Cats are magical. The more you pet them, the longer you both live.
— **Anonymous**

Clementine, Alexandria, VA

Photo by: Sara Robishaw

The sun rose slowly, like a fiery fur ball coughed up uneasily onto a
sky-blue carpet by a giant unseen cat.
— Michael McGarel

Meika, Mocksville, NC

Photo by: Amber Harris

The mathematical probability of a common cat doing exactly as it pleases is the one scientific absolute in the world.
— Lynn M. Osband

Periwinkle, Sandy Hook, CT

Photo by: Robin A.F. Olson, coveredincathair.com

As anyone who has ever been around a cat for any length of time well knows cats have enormous patience with the limitations of the human mind.
— Cleveland Amory

Haley, Astoria, NY

Photo by: Chris Caffery

Cats do care. For example they know instinctively what time we have to be at work in the morning and they wake us up twenty minutes before the alarm goes off.
–Michael Nelson

Allegra

Photo by: Ingrid King

The reason cats climb is so that they can look down on almost every other animal. It's also the reason they hate birds.
— **KC Buffington**

Kido, White Wind Zen Community, Ottawa

Photo by: Shikai Zuiko

I put down my book, "The Meaning of Zen," and see the cat smiling into her fur as she delicately combs it with her rough pink tongue. Cat, I would lend you this book to study but it appears you have already read it. She looks up and gives me her full gaze. Don't be ridiculous, she purrs. I wrote it.
— Dilys Laing

Amelie, Plymouth, MI

Photo by: Thea Bude

**A meow massages the heart.
– Stuart McMillan**

Venus de Meowlo, Lexington, KY

Photo by: Diane Kincaid

There's no need for a piece of sculpture in a home that has a cat.
— Wesley Bates

George, Madison, WI

Photo by: Heather Brandt

What greater gift than the love of a cat?
– Charles Dickens

Grit, Ellijay, GA

Photo by: Michelle Wolff

It was not I who was teaching my cat to gather rosebuds, but she who was teaching me.
– Irving Townsend

Buffy, Clarkesville, GA

Photo by: Kimberly Brown

A home without a cat, and a well-fed, well-petted and properly revered cat,
may be a perfect home, perhaps; but how can it prove its title?
– Mark Twain

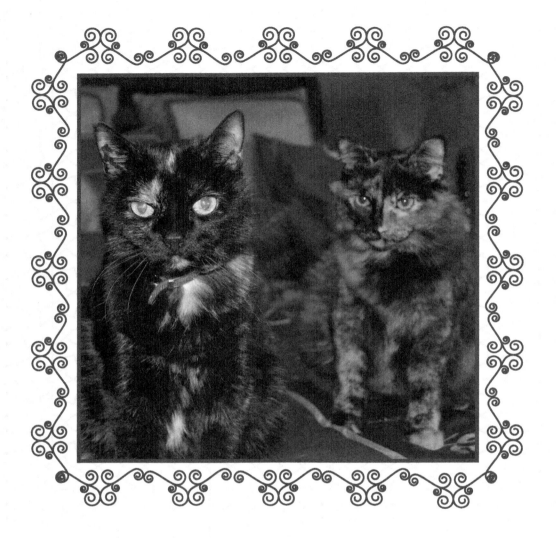

Doobie and Mazy, Omaha, NE

Photo by: Melody Diak

One cat just leads to another.
– Ernest Hemingway

Greta, Sandy Hook, CT

Photo by: Robin A.F. Olson, coveredincathair.com

"I meant," said Ipslore bitterly, "what is there in this world that truly makes living worthwhile?" Death thought about it. "Cats," he said eventually, "Cats are nice."
– Terry Pratchett, Sourcery

Aurora, Orlando, FL

Photo by: Diane Simmons

Cats are smarter than dogs. You can't get eight cats to pull a sled
through snow.
- Jeff Valdez

Amber

Photo by: Ingrid King

If we treated everyone we meet with the same affection we bestow upon our favorite cat, they, too, would purr.
— Martin Delany

Ruby

Photo by: Ingrid King

The smallest feline is a masterpiece.
- Leonardo DaVinci

Kid, Milford, CT

Photo by: Val Maloney

Women and cats will do as they please and men and dogs should
relax and get used to the idea.
- Robert A. Heinlein

Cinnaminnie, Sandy Hook, CT

Photo by: Robin A.F. Olson, coveredincathair.com

It is impossible to keep a straight face in the presence of one or more kittens.
– Cynthia E. Varnado

Caprica, New Bern, NC

Photo by: Kerri Settle King

In order to keep a true perspective of one's importance, everyone should have a dog that will worship him and a cat that will ignore him.
- Dereke Bruce

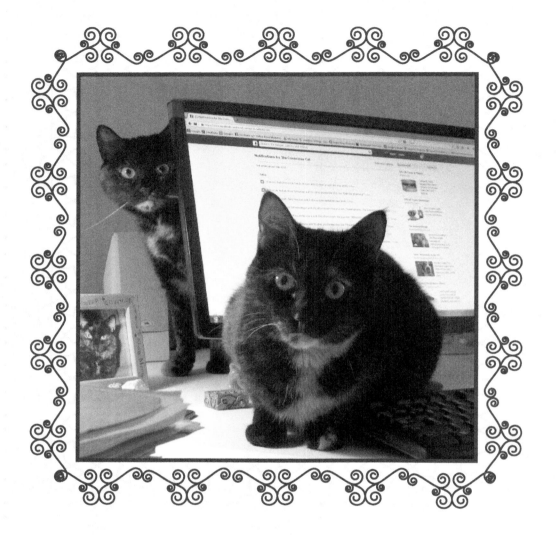

Ruby and Allegra

Photo by: Ingrid King

There are few things in life more heartwarming than to be welcomed by a cat.
-Tay Hohoff

Sita, Blue Springs, MO

Photo by: Katie Wiebers

If cats could talk, they wouldn't.
-Nan Porter

Haley, Astoria, NY

Photo by: Chris Caffery

There are two means of refuge from the misery of life — music and cats.
-Albert Schweitzer

Lucy, Frisco, TX

Photo by: Erin Hasan

There is something about the presence of a cat... that seems to take the bite out of being alone.
-Louis J. Camuti

Hazelnut, Pittsburgh, PA

Photo by: John Benstedt

Cats can work out mathematically the exact place to sit that will cause most inconvenience.
-Pam Brown

Allegra

Photo by: Ingrid King

If there is one spot of sun spilling onto the floor, a cat will find it and soak it up.
-J.A. McIntosh

Sissy, Seattle, WA

Photo by: Emily Fortuna

I believe cats to be spirits come to earth. A cat, I am sure, could walk on a
cloud without coming through.
-Jules Verne

Allegra

Photo by: Ingrid King

Even if you have just destroyed a Ming vase, purr. Usually, all will be forgiven.
– Lenny Rubenstein

Snoes, Hoogkarspel, The Netherlands

Photo by: Anita Botman

Purring would seem to be, in her case, an automatic safety valve device for
dealing with happiness overflow.
-Monica Edwards

Cocobean, Rahway, NJ

Photo by: Laurie Kutoroff

Like a graceful vase, a cat, even when motionless, seems to flow.
-George F. Will

Kajsa, Stockholm, Sweden

Photo by: Maria Timashans

The cat is the animal to whom the Creator gave the biggest eye, the softest fur, the most supremely delicate nostrils, a mobile ear, an unrivaled paw and a curved claw borrowed from the rose-tree.
-Colette

Gigi and Daisy, Windermere, FL

Photo by: Jodie Passwater

Although all cat games have their rules and rituals, these vary with the individual player. The cat, of course, never breaks a rule. If it does not follow precedent, that simply means it has created a new rule and it is up to you to learn it quickly if you want the game to continue.
-Sidney Denham

Amelie, Plymouth, MI

Photo by: Thea Bude

**People who love cats have some of the biggest hearts around.
– Susan Easterly**

Stirfry, Ephrata, PA

Photo by: Jay Davenport

Prowling his own quiet backyard or asleep by the fire, he is still only a
whisker away from the wilds.
-Jean Burden

Ziva, Murfreesboro, TN

Photo by: Sylvia Percy

I have studied many philosophers and many cats. The wisdom of cats is infinitely superior.
-Hippolyte Taine

Faith, Southampton, UK

Photo by: Jennie Dennison

Cats can be cooperative when something feels good, which, to a cat, is the way everything is supposed to feel as much of the time as possible.
-Roger Caras

Persephone, Muncy, PA

Photo by: Ashley Tyler

Way down deep, we're all motivated by the same urges. Cats have
the courage to live by them.
-Jim Davis

Kenzie with canine pal Jazzmyn, Magnolia, TX

Photo by: Linda Sparr

You can keep a dog; but it is the cat who keeps people, because cats find humans useful domestic animals.
-George Mikes

Norah, Mill Valley, CA

Photo by: Lawrence Newhouse

She clawed her way into my heart and wouldn't let go.
- Terri Guillemets

Pepper, Simi Valley, CA

Photo by: Kathryn Felt

Always the cat remains a little beyond the limits we try to set for him
in our blind folly.
-Andre Norton

Truffles, South Burlington, VT

Photo by: Melissa Lapierre

A catless writer is almost inconceivable; even Ernest Hemingway, manly follower of the hunting trophy and the bullfight, lived waist-deep in cats. It's a perverse taste, really, since it would be easier to write with a herd of buffalo in the room than even one cat; they make nests in the notes and bite the end of the pen and walk on the typewriter keys.
-Barbara Holland

Sophie Grace with Colby, Arnold, MD

Photo by: Jennifer Lockridge

The way to get on with a cat is to treat it as an equal - or even better, as the superior it knows itself to be.
-Elizabeth Peters

Sissy, Seattle, WA

Photo by: Emily Fortuna

Are we really sure the purring is coming from the kitty and not from
our very own hearts?
- Terri Guillemet

Carly, San Francisco, CA

Photo by: Carrie Scott

Cats have an infallible understanding of total concentration — and
get between you and it.
-Arthur Bridge

Persephone, Muncy, PA

Photo by: Ashley Tyler

If there were to be a universal sound depicting peace, I would
surely vote for the purr.
-Barbara L. Diamond

Indy, Northampton, England

Photo by: Lisa Curtis

The cat is nature's beauty.
– **French proverb**

Vivian, Galway, NY

Photo by: Kelly & Scott Young

A cat will be your friend, but never your slave.
- Theophile Gautier

Neko, Ellicot City, MD

Photo by: Stephanie Bartosz

God made the cat in order that man might have the pleasure of
caressing the lion.
- Fernand Mery

Amelia, Plymouth, MI

Photo by: Thea Bude

Cats are living adornments.
- Edwin Lent

Sophie Grace, Arnold, MD

Photo by: Jennifer Lockridge

Who could believe such pleasure from a wee ball o' fur?
- **Irish saying**

Saphira, Denver, NC

Photo by: Jamie Rasmussen

The only mystery about the cat is why it ever decided to become a domestic animal.
- Sir Compton Mackenzie

Siobhan and Bronwyn, Tacoma Park, MD

Photo by: Glynnis McPhee

Kittens learn early to listen intently when someone calls them - and
do absolutely nothing.
- Pam Brown

Sophie Grace, Arnold, MD

Photo by: Jennifer Lockridge

Her function is to sit and be admired.
- **Georgina Strickland Gates**

Bella, Bothell, WA

Photo by: Tricia Miller

To err is human, to purr feline.
- Robert Bryne

Mouse, Genoa, WI

Photo by: Jacquelyn Panktatz

The cat is a puzzle for which there is no solution.
- Hazel Nicholson

Nala, Fairfax, VA

Photo by: Keely Flatow

All cats are possessed of a proud spirit, and the surest way to forfeit the
esteem of a cat is to treat him as an inferior being.
– Michael Joseph

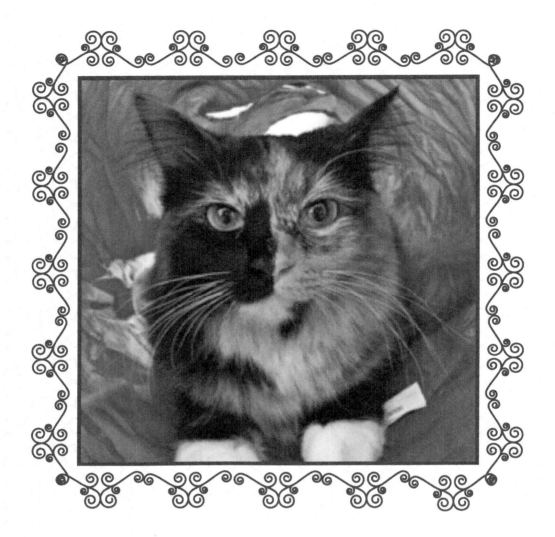

Misty, Ocala, FL

Photo by: Desiree Crosley

When I play with my cat, how do I know that she is not passing time
with me, rather than I with her.
– Montaigne

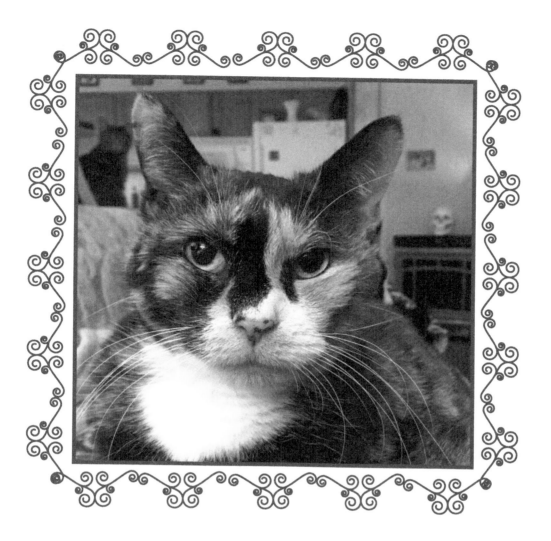

Tempie Toodles, Kenosha, WI

Photo by: Beth Hill

Cats were put into the world to disprove the dogma that all things
were created to serve man.
- **Paul Gray**

Ruby

Photo by: Ingrid King

They say the test of literary power is whether a man can write an
inscription. I say, "Can he name a kitten?"
- **Samuel Butler**

Stella, Chichester, NH

Photo by: Barbara Crawford

Cats are the connoisseurs of comfort.
- James Herriot

Acknowledgments

Being a writer is a solitary profession, but no book is created by the writer alone. This was never truer than for the creation of this one. Thank you "Team Tortitude" for sharing hundreds of photos of your beautiful torties with me. I wish I could have included all of them in this book.

I would also like to express my deepest appreciation to the following:

To my Conscious Cat readers, for being a part of our community and for reading and sharing what I write every day. I am honored and humbled that my writing is making a difference in so many lives, both feline and human.

To Kate Benjamin, for writing the beautiful foreword for this book. Thank you for being my friend and mentor.

To Jackson Galaxy and his entire team: your friendship and support mean the world to me.

To Harry Shubin and Diana Hamlet-Cox, PhD, for their help with the genetics portion of this book. Any errors are mine alone.

To everyone at Mango Media, for your enthusiasm about this book, and for making it a reality.

To my inner circle – you know who you are. I wouldn't be who I am without your friendship, encouragement and unwavering belief in me.

And last, but not least, to the torties who have come before, and the ones who are currently sharing my life. Amber, Buckley, Allegra and Ruby: thank you for the love, purrs, and tortitude.

About the Author

Ingrid King is the award-winning author of **Buckley's Story: Lessons from a Feline Master Teacher, Purrs of Wisdom: Conscious Living, Feline Style**, and **Adventures in Veterinary Medicine: What Working in Veterinary Hospitals Taught Me About Life, Love and Myself.** She is a former veterinary hospital manager. Her popular blog, The Conscious Cat, is a comprehensive resource for conscious living, health, and happiness for cats and their humans. The Conscious Cat has won multiple awards, including DogTime Media's Pettie for Best Pet Blog in 2011, 2012, 2013, and 2014, and About.com's 2012 Readers Choice Award for Best Website About Cats. Ingrid lives in Northern Virginia with her tortoiseshell cats Allegra and Ruby. For more information about Ingrid, please visit **www.ConsciousCat.com.**

Ingrid King with Ruby

Do you have questions or comments?

I'd love to hear your thoughts. E-mail me at **consciouscat@cox.net**.

If you're not already a reader of The Conscious Cat, I'd love to invite you to join one of the best communities of cat lovers on the Internet: **www.Consciouscat.com**

One last thing

If you have enjoyed this book, I would love it if you would take a few moments to post a review on Amazon or share it with your cat loving friends on Facebook and Twitter.

CPSIA information can be obtained at www.ICGtesting.com
Printed in the USA
BVOW07*0834271215

430967BV00011B/30/P